NICOTEXT

MY REVIEWS DATES

The publisher and authors disclaim any liability that may result from the use of the information contained in this book. All the information in this book comes directly from experts but we do not guarantee that the information contained herein is complete or accurate. The content of this book is the author's opinion and not necessarily that of NICOTEXT.

No part of this book may be used or reproduced in any manner whatsoever without the written permission except in the case of reprints of the context of reviews.
For information, email info@nicotext.com

Copyright © NICOTEXT 2007 All rights reserved.
NICOTEXT part of Cladd media ltd.

ISBN: 978-91-85449-29-3
Printed in Poland

Attention: Schools and Businesses!
NICOTEXT books are available at quantity discounts with bulk purchase for educational, business, or sales promotion use. For information, please email:
info@nicotext.com

www.nicotext.com

THIS IS ME:

My name is:

I first started dating:

I date:

Every week []
Every month []
Every year []
Other:

Who asks:

I ask people out []
I get asked out []

These are my requirements for dating someone:

These are some of my best moves to impress a date:

Sex on the first date:

Yes []
No []
By accident only []
Other:

Record number of dates in one week:

Two []
Five []
I'm a slut []

Favorite pick-up line:

Lamest pick-up line:

People I plan to date in the future:

I'd like to date this person, but I would never dare tell my friends:

TOP TEN PLACES TO DATE:

1: ..

2: ..

3: ..

4: ..

5: ..

6: ..

7: ..

8: ..

9: ..

10: ..

CELEBRITIES I'D LIKE TO DATE:

1: ...

2: ...

3: ...

4: ...

5: ...

6: ...

7: ...

8: ...

9: ...

10: ..

ASKING SOMEONE OUT ON A DATE:

According to a study done at the University of Chicago, there is no such thing as a pick-up line that really works. Apparently, "Hi" is the best opening line there is, followed by a question such as "How do you like the band?" or "So, what brings you here?".

1. Find someone you wish to date.
2. Go up to that person. Walk with your head held high. But watch where you are going.
3. Get eye contact.
4. Smile.
5. Open your mouth.
6. Say: Hi.
7. Say: I'm (your name).
8. Nine times out of ten you'll get some sort of reaction.
9. Follow it up with a question. Say: How do you like the band, or, what brings you here, or, I just feel like talking to you.
10. Contact has now been established.
11. Continue talking wherever it takes you.
12. Keep it short.
13. Before leaving, casually pop the question.
14. Say: Do you want to go out sometime?
15. This should provoke a reply.
16. Numbers are exchanged.
17. Smile and say: I'll call you.
18. You depart with a smile.

DESCRIBE YOUR DREAM DATE:

..

..

..

..

..

DESCRIBE THE BEST DATE YOU'VE EVER BEEN ON:

..

..

..

..

..

DESCRIBE THE WORST DATE YOU'VE EVER BEEN ON:

..

..

..

..

..

DATE TELEPHONE NUMBERS:

You're alone, it's Friday, you don't have a date, who are you gonna call? No, not Ghostbusters but perhaps someone below.

DATING ICEBREAKERS:

Did you know…

…that in North America there are approximately 618 roller coasters?

…that every day 20 banks are robbed? The average take is $2,500!

…that the names of Popeye's four nephews are Pipeye, Peepeye, Pupeye, and Poopeye?

…that it takes one million years for glass to decompose?

… that no piece of square, dry paper can be folded in half more than seven times?

…that over 2,500 left handed people are killed each year by using products made for right handed people?

…that the sentence "the quick brown fox jumps over a lazy dog" uses every letter of the alphabet?

…that dolphins sleep with one eye open?

…that there are more plastic flamingos in the U.S. than real ones?

…that more people use blue toothbrushes, than red ones?

…that recycling one glass jar, saves enough energy to watch TV for three hours?

…that you'll eat about 35,000 cookies in a lifetime?

…that like fingerprints, everyone's tongue print is different?

…that a man named Charles Osborne had the hiccups for 69 years?

GREAT THINGS TO DO ON A DATE:

TAKE A RIDE IN A CONVERTIBLE.

GO ON A MERRY GO ROUND.

HIKE UP A MOUNTAIN. BRING A PICNIC.

GO TO A CONCERT.

LEARN TO COOK INDIAN FOOD.

GO TO THE DEAD SEA AND FLOAT AROUND ON YOUR BODIES.

HAVE A STARING CONTEST.

GO TO A SHOOTING RANGE.

PAINT A HOUSE.

WALK DOGS.

GO BULLRIDING.

GO MIDGET SPOTTING.

DANCE SALSA.

RIDE ON A BUS OR THE SUBWAY UNTIL YOU GET TIRED.

CLIMB A TREE.

DISCOVER TEN DIFFERENT WAYS OF KISSING.

BURY A TREASURE.

GO TO THE ZOO AND IMITATE THE MONKEYS.

LIST YOUR FAVORITES.

CUT EACH OTHERS HAIR.

FLY A KITE.

GO FOR A WALK.

DATE EMERGENCY EXITS:
WHEN THINGS GO BAD. HERE'S YOUR WAY OUT.

I have to feed my dog.

I have to return some videotapes.

I'm leaving the country tomorrow.

I have diarrhea.

I just remembered, I have a dentist appointment.

The voices in my head say we should get married.

I just realized I forgot my wallet, I'll be right back (not).

I'm on call at the hospital.

I have a terrible headache.

I feel my Tourette's acting up. TIT! TITTIES!

I don't like you.

I'm married with three kids.

Oh, look at that pink moose (then run the other way).

Excuse me while I go and buy some condoms.

I feel very tired tonight because I just had brain surgery.

MY DATES

My date's name:

When the date took place:

Where and how we met:

Date-rating 1-10
(1 meaning I would rather poke a stick in my eye, and 10 I can't wait to get married)

1 2 3 4 5 6 7 8 9 10

Was it the first date with this person?

Yes []
No []

My feelings before the date:

Nervous []
Calm []
Anxious []
Blue []
Horny []
Bored []
Happy []
Other:

My first impression:

I was wearing:

My date was wearing:

Where the date took place:

Restaurant　　　　[]
Cinema　　　　　[]
Café　　　　　　 []
Shooting range　 []
Other:

Activities. What we did during the date:

My dates occupation:

Something fun I found out about my date:

Who paid for the date:

Me　　　　[]
My date　 []
Dutch　　 []

The first thing that pops up when I think about my date:

This is what my parents would have thought about my date:

The things I like most about my date:

Looks []
Personality []
Humour []
Financial stability []
Other:

The things I liked least about my date:

Something embarrasing that happened during the date:

What I think my date thought about me:

The date ended with:

Handshake []
Hug []
Kiss []
Sex []
Marriage []
Other:

How I wish the date would have ended:

The kind of relationship I'm hoping for with this date:

None []
Friendship []
Sexual []
Move in []
Marriage []
Raise rugrats []
Other:

Will there be another date:

Yes []
No []

Notes: ..
..
..
..
..
..
..
..

My date's name:

When the date took place:

Where and how we met:

Date-rating 1-10
(1 meaning I would rather poke a stick in my eye, and 10 I can't wait to get married)

1 2 3 4 5 6 7 8 9 10

Was it the first date with this person?

Yes []
No []

My feelings before the date:

Nervous []
Calm []
Anxious []
Blue []
Horny []
Bored []
Happy []
Other:

My first impression:

I was wearing:

My date was wearing:

Where the date took place:

Restaurant []
Cinema []
Café []
Shooting range []
Other:

Activities. What we did during the date:

My dates occupation:

Something fun I found out about my date:

Who paid for the date:

Me []
My date []
Dutch []

The first thing that pops up when I think about my date:

This is what my parents would have thought about my date:

The things I like most about my date:

Looks []
Personality []
Humour []
Financial stability []
Other:

The things I liked least about my date:

Something embarrasing that happened during the date:

What I think my date thought about me:

The date ended with:

Handshake []
Hug []
Kiss []
Sex []
Marriage []
Other:

How I wish the date would have ended:

The kind of relationship I'm hoping for with this date:

None []
Friendship []
Sexual []
Move in []
Marriage []
Raise rugrats []
Other:

Will there be another date:

Yes []
No []

Notes: ...
..
..
..
..
..
..
..
..

My date's name:

When the date took place:

Where and how we met:

Date-rating 1-10
(1 meaning I would rather poke a stick in my eye, and 10 I can't wait to get married)

1 2 3 4 5 6 7 8 9 10

Was it the first date with this person?

Yes []
No []

My feelings before the date:

Nervous	[]
Calm	[]
Anxious	[]
Blue	[]
Horny	[]
Bored	[]
Happy	[]
Other:	

My first impression:

I was wearing:

My date was wearing:

Where the date took place:

Restaurant			[]
Cinema			[]
Café				[]
Shooting range		[]
Other:

Activities. What we did during the date:

My dates occupation:

Something fun I found out about my date:

Who paid for the date:

Me			[]
My date		[]
Dutch			[]

The first thing that pops up when I think about my date:

This is what my parents would have thought about my date:

The things I like most about my date:

Looks []
Personality []
Humour []
Financial stability []
Other:

The things I liked least about my date:

Something embarrasing that happened during the date:

What I think my date thought about me:

The date ended with:

Handshake []
Hug []
Kiss []
Sex []
Marriage []
Other:

How I wish the date would have ended:

The kind of relationship I'm hoping for with this date:

None []
Friendship []
Sexual []
Move in []
Marriage []
Raise rugrats []
Other:

Will there be another date:

Yes []
No []

Notes: ..
..
..
..
..
..
..
..

My date's name:

When the date took place:

Where and how we met:

Date-rating 1-10
(1 meaning I would rather poke a stick in my eye, and 10 I can't wait to get married)

1 2 3 4 5 6 7 8 9 10

Was it the first date with this person?

Yes []
No []

My feelings before the date:

Nervous	[]
Calm	[]
Anxious	[]
Blue	[]
Horny	[]
Bored	[]
Happy	[]

Other:

My first impression:

I was wearing:

My date was wearing:

Where the date took place:

Restaurant []
Cinema []
Café []
Shooting range []
Other:

Activities. What we did during the date:

My dates occupation:

Something fun I found out about my date:

Who paid for the date:

Me []
My date []
Dutch []

The first thing that pops up when I think about my date:

This is what my parents would have thought about my date:

The things I like most about my date:

Looks []
Personality []
Humour []
Financial stability []
Other:

The things I liked least about my date:

Something embarrasing that happened during the date:

What I think my date thought about me:

The date ended with:

Handshake []
Hug []
Kiss []
Sex []
Marriage []
Other:

How I wish the date would have ended:

The kind of relationship I'm hoping for with this date:

None []
Friendship []
Sexual []
Move in []
Marriage []
Raise rugrats []
Other:

Will there be another date:

Yes []
No []

Notes: ..
..
..
..
..
..
..
..

My date's name:

When the date took place:

Where and how we met:

Date-rating 1-10
(1 meaning I would rather poke a stick in my eye, and 10 I can't wait to get married)

1 2 3 4 5 6 7 8 9 10

Was it the first date with this person?

Yes　　[]
No　　[]

My feelings before the date:

Nervous	[]
Calm	[]
Anxious	[]
Blue	[]
Horny	[]
Bored	[]
Happy	[]

Other:

My first impression:

I was wearing:

My date was wearing:

Where the date took place:

Restaurant []
Cinema []
Café []
Shooting range []
Other:

Activities. What we did during the date:

My dates occupation:

Something fun I found out about my date:

Who paid for the date:

Me []
My date []
Dutch []

The first thing that pops up when I think about my date:

This is what my parents would have thought about my date:

The things I like most about my date:

Looks []
Personality []
Humour []
Financial stability []
Other:

The things I liked least about my date:

Something embarrasing that happened during the date:

What I think my date thought about me:

The date ended with:

Handshake []
Hug []
Kiss []
Sex []
Marriage []
Other:

How I wish the date would have ended:

The kind of relationship I'm hoping for with this date:

None []
Friendship []
Sexual []
Move in []
Marriage []
Raise rugrats []
Other:

Will there be another date:

Yes []
No []

Notes: ..
..
..
..
..
..
..
..

My date's name:

When the date took place:

Where and how we met:

Date-rating 1-10
(1 meaning I would rather poke a stick in my eye, and 10 I can't wait to get married)

1 2 3 4 5 6 7 8 9 10

Was it the first date with this person?

Yes []
No []

My feelings before the date:

Nervous []
Calm []
Anxious []
Blue []
Horny []
Bored []
Happy []
Other:

My first impression:

I was wearing:

My date was wearing:

Where the date took place:

Restaurant []
Cinema []
Café []
Shooting range []
Other:

Activities. What we did during the date:

My dates occupation:

Something fun I found out about my date:

Who paid for the date:

Me []
My date []
Dutch []

The first thing that pops up when I think about my date:

This is what my parents would have thought about my date:

The things I like most about my date:

Looks	[]
Personality	[]
Humour	[]
Financial stability	[]

Other:

The things I liked least about my date:

Something embarrasing that happened during the date:

What I think my date thought about me:

The date ended with:

Handshake []
Hug []
Kiss []
Sex []
Marriage []
Other:

How I wish the date would have ended:

The kind of relationship I'm hoping for with this date:

None []
Friendship []
Sexual []
Move in []
Marriage []
Raise rugrats []
Other:

Will there be another date:

Yes []
No []

Notes: ..
..
..
..
..
..
..
..
..

My date's name:

When the date took place:

Where and how we met:

Date-rating 1-10
(1 meaning I would rather poke a stick in my eye, and 10 I can't wait to get married)

1 2 3 4 5 6 7 8 9 10

Was it the first date with this person?

Yes []
No []

My feelings before the date:

Nervous	[]
Calm	[]
Anxious	[]
Blue	[]
Horny	[]
Bored	[]
Happy	[]

Other:

My first impression:

I was wearing:

My date was wearing:

Where the date took place:

Restaurant []
Cinema []
Café []
Shooting range []
Other:

Activities. What we did during the date:

My dates occupation:

Something fun I found out about my date:

Who paid for the date:

Me []
My date []
Dutch []

The first thing that pops up when I think about my date:

This is what my parents would have thought about my date:

The things I like most about my date:

Looks []
Personality []
Humour []
Financial stability []
Other:

The things I liked least about my date:

Something embarrasing that happened during the date:

What I think my date thought about me:

The date ended with:

Handshake []
Hug []
Kiss []
Sex []
Marriage []
Other:

How I wish the date would have ended:

The kind of relationship I'm hoping for with this date:

None []
Friendship []
Sexual []
Move in []
Marriage []
Raise rugrats []
Other:

Will there be another date:

Yes []
No []

Notes: ..
..
..
..
..
..
..
..
..

My date's name:

When the date took place:

Where and how we met:

Date-rating 1-10
(1 meaning I would rather poke a stick in my eye, and 10 I can't wait to get married)

1 2 3 4 5 6 7 8 9 10

Was it the first date with this person?

Yes []
No []

My feelings before the date:

Nervous []
Calm []
Anxious []
Blue []
Horny []
Bored []
Happy []
Other:

My first impression:

I was wearing:

My date was wearing:

Where the date took place:

Restaurant []
Cinema []
Café []
Shooting range []
Other:

Activities. What we did during the date:

My dates occupation:

Something fun I found out about my date:

Who paid for the date:

Me []
My date []
Dutch []

The first thing that pops up when I think about my date:

This is what my parents would have thought about my date:

The things I like most about my date:

Looks []
Personality []
Humour []
Financial stability []
Other:

The things I liked least about my date:

Something embarrasing that happened during the date:

What I think my date thought about me:

The date ended with:

Handshake []
Hug []
Kiss []
Sex []
Marriage []
Other:

How I wish the date would have ended:

The kind of relationship I'm hoping for with this date:

None []
Friendship []
Sexual []
Move in []
Marriage []
Raise rugrats []
Other:

Will there be another date:

Yes []
No []

Notes: ..
..
..
..
..
..
..
..
..

My date's name:

When the date took place:

Where and how we met:

Date-rating 1-10
(1 meaning I would rather poke a stick in my eye, and 10 I can't wait to get married)

1 2 3 4 5 6 7 8 9 10

Was it the first date with this person?

Yes []
No []

My feelings before the date:

Nervous []
Calm []
Anxious []
Blue []
Horny []
Bored []
Happy []
Other:

My first impression:

I was wearing:

My date was wearing:

Where the date took place:

Restaurant []
Cinema []
Café []
Shooting range []
Other:

Activities. What we did during the date:

My dates occupation:

Something fun I found out about my date:

Who paid for the date:

Me []
My date []
Dutch []

The first thing that pops up when I think about my date:

This is what my parents would have thought about my date:

The things I like most about my date:

Looks []
Personality []
Humour []
Financial stability []
Other:

The things I liked least about my date:

Something embarrasing that happened during the date:

What I think my date thought about me:

The date ended with:

Handshake []
Hug []
Kiss []
Sex []
Marriage []
Other:

How I wish the date would have ended:

The kind of relationship I'm hoping for with this date:

None []
Friendship []
Sexual []
Move in []
Marriage []
Raise rugrats []
Other:

Will there be another date:

Yes []
No []

Notes: ...
..
..
..
..
..
..
..

My date's name:

When the date took place:

Where and how we met:

Date-rating 1-10
(1 meaning I would rather poke a stick in my eye, and 10 I can't wait to get married)

1 2 3 4 5 6 7 8 9 10

Was it the first date with this person?

Yes []
No []

My feelings before the date:

Nervous	[]
Calm	[]
Anxious	[]
Blue	[]
Horny	[]
Bored	[]
Happy	[]

Other:

My first impression:

I was wearing:

My date was wearing:

Where the date took place:

Restaurant []
Cinema []
Café []
Shooting range []
Other:

Activities. What we did during the date:

My dates occupation:

Something fun I found out about my date:

Who paid for the date:

Me []
My date []
Dutch []

The first thing that pops up when I think about my date:

This is what my parents would have thought about my date:

The things I like most about my date:

Looks []
Personality []
Humour []
Financial stability []
Other:

The things I liked least about my date:

Something embarrasing that happened during the date:

What I think my date thought about me:

The date ended with:

Handshake []
Hug []
Kiss []
Sex []
Marriage []
Other:

How I wish the date would have ended:

The kind of relationship I'm hoping for with this date:

None []
Friendship []
Sexual []
Move in []
Marriage []
Raise rugrats []
Other:

Will there be another date:

Yes []
No []

Notes: ..
..
..
..
..
..
..
..

My date's name:

When the date took place:

Where and how we met:

Date-rating 1-10
(1 meaning I would rather poke a stick in my eye, and 10 I can't wait to get married)

1 2 3 4 5 6 7 8 9 10

Was it the first date with this person?

Yes []
No []

My feelings before the date:

Nervous []
Calm []
Anxious []
Blue []
Horny []
Bored []
Happy []
Other:

My first impression:

I was wearing:

My date was wearing:

Where the date took place:

Restaurant []
Cinema []
Café []
Shooting range []
Other:

Activities. What we did during the date:

My dates occupation:

Something fun I found out about my date:

Who paid for the date:

Me []
My date []
Dutch []

The first thing that pops up when I think about my date:

This is what my parents would have thought about my date:

The things I like most about my date:

Looks []
Personality []
Humour []
Financial stability []
Other:

The things I liked least about my date:

Something embarrasing that happened during the date:

What I think my date thought about me:

The date ended with:

Handshake []
Hug []
Kiss []
Sex []
Marriage []
Other:

How I wish the date would have ended:

The kind of relationship I'm hoping for with this date:

None []
Friendship []
Sexual []
Move in []
Marriage []
Raise rugrats []
Other:

Will there be another date:

Yes []
No []

Notes: ..
..
..
..
..
..
..
..

My date's name:

When the date took place:

Where and how we met:

Date-rating 1-10
(1 meaning I would rather poke a stick in my eye, and 10 I can't wait to get married)

1 2 3 4 5 6 7 8 9 10

Was it the first date with this person?

Yes []
No []

My feelings before the date:

Nervous []
Calm []
Anxious []
Blue []
Horny []
Bored []
Happy []
Other:

My first impression:

I was wearing:

My date was wearing:

Where the date took place:

Restaurant []
Cinema []
Café []
Shooting range []
Other:

Activities. What we did during the date:

My dates occupation:

Something fun I found out about my date:

Who paid for the date:

Me []
My date []
Dutch []

The first thing that pops up when I think about my date:

This is what my parents would have thought about my date:

The things I like most about my date:

Looks []
Personality []
Humour []
Financial stability []
Other:

The things I liked least about my date:

Something embarrasing that happened during the date:

What I think my date thought about me:

The date ended with:

Handshake	[]
Hug	[]
Kiss	[]
Sex	[]
Marriage	[]

Other:

How I wish the date would have ended:

The kind of relationship I'm hoping for with this date:

None	[]
Friendship	[]
Sexual	[]
Move in	[]
Marriage	[]
Raise rugrats	[]

Other:

Will there be another date:

| Yes | [] |
| No | [] |

Notes: ..
..
..
..
..
..
..
..

My date's name:

When the date took place:

Where and how we met:

Date-rating 1-10
(1 meaning I would rather poke a stick in my eye, and 10 I can't wait to get married)

1 2 3 4 5 6 7 8 9 10

Was it the first date with this person?

Yes []
No []

My feelings before the date:

Nervous []
Calm []
Anxious []
Blue []
Horny []
Bored []
Happy []
Other:

My first impression:

I was wearing:

My date was wearing:

Where the date took place:

Restaurant		[]
Cinema			[]
Café			[]
Shooting range		[]
Other:

Activities. What we did during the date:

My dates occupation:

Something fun I found out about my date:

Who paid for the date:

Me			[]
My date			[]
Dutch			[]

The first thing that pops up when I think about my date:

This is what my parents would have thought about my date:

The things I like most about my date:

Looks []
Personality []
Humour []
Financial stability []
Other:

The things I liked least about my date:

Something embarrasing that happened during the date:

What I think my date thought about me:

The date ended with:

Handshake []
Hug []
Kiss []
Sex []
Marriage []
Other:

How I wish the date would have ended:

The kind of relationship I'm hoping for with this date:

None []
Friendship []
Sexual []
Move in []
Marriage []
Raise rugrats []
Other:

Will there be another date:

Yes []
No []

Notes:

My date's name:

When the date took place:

Where and how we met:

Date-rating 1-10
(1 meaning I would rather poke a stick in my eye, and 10 I can't wait to get married)

1 2 3 4 5 6 7 8 9 10

Was it the first date with this person?

Yes []
No []

My feelings before the date:

Nervous	[]
Calm	[]
Anxious	[]
Blue	[]
Horny	[]
Bored	[]
Happy	[]

Other:

My first impression:

I was wearing:

My date was wearing:

Where the date took place:

Restaurant []
Cinema []
Café []
Shooting range []
Other:

Activities. What we did during the date:

My dates occupation:

Something fun I found out about my date:

Who paid for the date:

Me []
My date []
Dutch []

The first thing that pops up when I think about my date:

This is what my parents would have thought about my date:

The things I like most about my date:

Looks []
Personality []
Humour []
Financial stability []
Other:

The things I liked least about my date:

Something embarrasing that happened during the date:

What I think my date thought about me:

The date ended with:

Handshake []
Hug []
Kiss []
Sex []
Marriage []
Other:

How I wish the date would have ended:

The kind of relationship I'm hoping for with this date:

None []
Friendship []
Sexual []
Move in []
Marriage []
Raise rugrats []
Other:

Will there be another date:

Yes []
No []

Notes:

My date's name:

When the date took place:

Where and how we met:

Date-rating 1-10
(1 meaning I would rather poke a stick in my eye, and 10 I can't wait to get married)

1 2 3 4 5 6 7 8 9 10

Was it the first date with this person?

Yes []
No []

My feelings before the date:

Nervous	[]
Calm	[]
Anxious	[]
Blue	[]
Horny	[]
Bored	[]
Happy	[]

Other:

My first impression:

I was wearing:

My date was wearing:

Where the date took place:

Restaurant []
Cinema []
Café []
Shooting range []
Other:

Activities. What we did during the date:

My dates occupation:

Something fun I found out about my date:

Who paid for the date:

Me []
My date []
Dutch []

The first thing that pops up when I think about my date:

This is what my parents would have thought about my date:

The things I like most about my date:

Looks []
Personality []
Humour []
Financial stability []
Other:

The things I liked least about my date:

Something embarrasing that happened during the date:

What I think my date thought about me:

The date ended with:

Handshake []
Hug []
Kiss []
Sex []
Marriage []
Other:

How I wish the date would have ended:

The kind of relationship I'm hoping for with this date:

None []
Friendship []
Sexual []
Move in []
Marriage []
Raise rugrats []
Other:

Will there be another date:

Yes []
No []

Notes: ..
..
..
..
..
..
..
..

My date's name:

When the date took place:

Where and how we met:

Date-rating 1-10
(1 meaning I would rather poke a stick in my eye, and 10 I can't wait to get married)

1 2 3 4 5 6 7 8 9 10

Was it the first date with this person?

Yes []
No []

My feelings before the date:

Nervous	[]
Calm	[]
Anxious	[]
Blue	[]
Horny	[]
Bored	[]
Happy	[]

Other:

My first impression:

I was wearing:

My date was wearing:

Where the date took place:

Restaurant []
Cinema []
Café []
Shooting range []
Other:

Activities. What we did during the date:

My dates occupation:

Something fun I found out about my date:

Who paid for the date:

Me []
My date []
Dutch []

The first thing that pops up when I think about my date:

This is what my parents would have thought about my date:

The things I like most about my date:

Looks []
Personality []
Humour []
Financial stability []
Other:

The things I liked least about my date:

Something embarrasing that happened during the date:

What I think my date thought about me:

The date ended with:

Handshake []
Hug []
Kiss []
Sex []
Marriage []
Other:

How I wish the date would have ended:

The kind of relationship I'm hoping for with this date:

None []
Friendship []
Sexual []
Move in []
Marriage []
Raise rugrats []
Other:

Will there be another date:

Yes []
No []

Notes: ...
..
..
..
..
..
..
..

My date's name:

When the date took place:

Where and how we met:

Date-rating 1-10
(1 meaning I would rather poke a stick in my eye, and 10 I can't wait to get married)

1 2 3 4 5 6 7 8 9 10

Was it the first date with this person?

Yes []
No []

My feelings before the date:

Nervous []
Calm []
Anxious []
Blue []
Horny []
Bored []
Happy []
Other:

My first impression:

I was wearing:

My date was wearing:

Where the date took place:

Restaurant []
Cinema []
Café []
Shooting range []
Other:

Activities. What we did during the date:

My dates occupation:

Something fun I found out about my date:

Who paid for the date:

Me []
My date []
Dutch []

The first thing that pops up when I think about my date:

This is what my parents would have thought about my date:

The things I like most about my date:

Looks []
Personality []
Humour []
Financial stability []
Other:

The things I liked least about my date:

Something embarrasing that happened during the date:

What I think my date thought about me:

The date ended with:

Handshake []
Hug []
Kiss []
Sex []
Marriage []
Other:

How I wish the date would have ended:

The kind of relationship I'm hoping for with this date:

None []
Friendship []
Sexual []
Move in []
Marriage []
Raise rugrats []
Other:

Will there be another date:

Yes []
No []

Notes: ..
..
..
..
..
..
..
..

My date's name:

When the date took place:

Where and how we met:

Date-rating 1-10
(1 meaning I would rather poke a stick in my eye, and 10 I can't wait to get married)

1 2 3 4 5 6 7 8 9 10

Was it the first date with this person?

Yes []
No []

My feelings before the date:

Nervous []
Calm []
Anxious []
Blue []
Horny []
Bored []
Happy []
Other:

My first impression:

I was wearing:

My date was wearing:

Where the date took place:

Restaurant []
Cinema []
Café []
Shooting range []
Other:

Activities. What we did during the date:

My dates occupation:

Something fun I found out about my date:

Who paid for the date:

Me []
My date []
Dutch []

The first thing that pops up when I think about my date:

This is what my parents would have thought about my date:

The things I like most about my date:

Looks []
Personality []
Humour []
Financial stability []
Other:

The things I liked least about my date:

Something embarrasing that happened during the date:

What I think my date thought about me:

The date ended with:

Handshake []
Hug []
Kiss []
Sex []
Marriage []
Other:

How I wish the date would have ended:

The kind of relationship I'm hoping for with this date:

None []
Friendship []
Sexual []
Move in []
Marriage []
Raise rugrats []
Other:

Will there be another date:

Yes []
No []

Notes: ..
..
..
..
..
..
..
..
..

My date's name:

When the date took place:

Where and how we met:

Date-rating 1-10
(1 meaning I would rather poke a stick in my eye, and 10 I can't wait to get married)

1 2 3 4 5 6 7 8 9 10

Was it the first date with this person?

Yes []
No []

My feelings before the date:

Nervous	[]
Calm	[]
Anxious	[]
Blue	[]
Horny	[]
Bored	[]
Happy	[]

Other:

My first impression:

I was wearing:

My date was wearing:

Where the date took place:

Restaurant []
Cinema []
Café []
Shooting range []
Other:

Activities. What we did during the date:

My dates occupation:

Something fun I found out about my date:

Who paid for the date:

Me []
My date []
Dutch []

The first thing that pops up when I think about my date:

This is what my parents would have thought about my date:

The things I like most about my date:

Looks []
Personality []
Humour []
Financial stability []
Other:

The things I liked least about my date:

Something embarrasing that happened during the date:

What I think my date thought about me:

The date ended with:

Handshake []
Hug []
Kiss []
Sex []
Marriage []
Other:

How I wish the date would have ended:

The kind of relationship I'm hoping for with this date:

None []
Friendship []
Sexual []
Move in []
Marriage []
Raise rugrats []
Other:

Will there be another date:

Yes []
No []

Notes: ..
..
..
..
..
..
..
..

My date's name:

When the date took place:

Where and how we met:

Date-rating 1-10
(1 meaning I would rather poke a stick in my eye, and 10 I can't wait to get married)

1 2 3 4 5 6 7 8 9 10

Was it the first date with this person?

Yes []
No []

My feelings before the date:

Nervous	[]
Calm	[]
Anxious	[]
Blue	[]
Horny	[]
Bored	[]
Happy	[]

Other:

My first impression:

I was wearing:

My date was wearing:

Where the date took place:

Restaurant []
Cinema []
Café []
Shooting range []
Other:

Activities. What we did during the date:

My dates occupation:

Something fun I found out about my date:

Who paid for the date:

Me []
My date []
Dutch []

The first thing that pops up when I think about my date:

This is what my parents would have thought about my date:

The things I like most about my date:

Looks []
Personality []
Humour []
Financial stability []
Other:

The things I liked least about my date:

Something embarrasing that happened during the date:

What I think my date thought about me:

The date ended with:

Handshake []
Hug []
Kiss []
Sex []
Marriage []
Other:

How I wish the date would have ended:

The kind of relationship I'm hoping for with this date:

None []
Friendship []
Sexual []
Move in []
Marriage []
Raise rugrats []
Other:

Will there be another date:

Yes []
No []

Notes:

My date's name:

When the date took place:

Where and how we met:

Date-rating 1-10
(1 meaning I would rather poke a stick in my eye, and 10 I can't wait to get married)

1 2 3 4 5 6 7 8 9 10

Was it the first date with this person?

Yes []
No []

My feelings before the date:

Nervous []
Calm []
Anxious []
Blue []
Horny []
Bored []
Happy []
Other:

My first impression:

I was wearing:

My date was wearing:

Where the date took place:

Restaurant []
Cinema []
Café []
Shooting range []
Other:

Activities. What we did during the date:

My dates occupation:

Something fun I found out about my date:

Who paid for the date:

Me []
My date []
Dutch []

The first thing that pops up when I think about my date:

This is what my parents would have thought about my date:

The things I like most about my date:

Looks []
Personality []
Humour []
Financial stability []
Other:

The things I liked least about my date:

Something embarrasing that happened during the date:

What I think my date thought about me:

The date ended with:

Handshake []
Hug []
Kiss []
Sex []
Marriage []
Other:

How I wish the date would have ended:

The kind of relationship I'm hoping for with this date:

None []
Friendship []
Sexual []
Move in []
Marriage []
Raise rugrats []
Other:

Will there be another date:

Yes []
No []

Notes: ..
..
..
..
..
..
..
..
..

My date's name:

When the date took place:

Where and how we met:

Date-rating 1-10
(1 meaning I would rather poke a stick in my eye, and 10 I can't wait to get married)

1 2 3 4 5 6 7 8 9 10

Was it the first date with this person?

Yes []
No []

My feelings before the date:

Nervous []
Calm []
Anxious []
Blue []
Horny []
Bored []
Happy []
Other:

My first impression:

I was wearing:

My date was wearing:

Where the date took place:

Restaurant []
Cinema []
Café []
Shooting range []
Other:

Activities. What we did during the date:

My dates occupation:

Something fun I found out about my date:

Who paid for the date:

Me []
My date []
Dutch []

The first thing that pops up when I think about my date:

This is what my parents would have thought about my date:

The things I like most about my date:

Looks []
Personality []
Humour []
Financial stability []
Other:

The things I liked least about my date:

Something embarrasing that happened during the date:

What I think my date thought about me:

The date ended with:

Handshake []
Hug []
Kiss []
Sex []
Marriage []
Other:

How I wish the date would have ended:

The kind of relationship I'm hoping for with this date:

None []
Friendship []
Sexual []
Move in []
Marriage []
Raise rugrats []
Other:

Will there be another date:

Yes []
No []

Notes: ..
..
..
..
..
..
..
..
..

My date's name:

When the date took place:

Where and how we met:

Date-rating 1-10
(1 meaning I would rather poke a stick in my eye, and 10 I can't wait to get married)

1 2 3 4 5 6 7 8 9 10

Was it the first date with this person?

Yes []
No []

My feelings before the date:

Nervous	[]
Calm	[]
Anxious	[]
Blue	[]
Horny	[]
Bored	[]
Happy	[]

Other:

My first impression:

I was wearing:

My date was wearing:

Where the date took place:

Restaurant []
Cinema []
Café []
Shooting range []
Other:

Activities. What we did during the date:

My dates occupation:

Something fun I found out about my date:

Who paid for the date:

Me []
My date []
Dutch []

The first thing that pops up when I think about my date:

This is what my parents would have thought about my date:

The things I like most about my date:

Looks []
Personality []
Humour []
Financial stability []
Other:

The things I liked least about my date:

Something embarrasing that happened during the date:

What I think my date thought about me:

The date ended with:

Handshake []
Hug []
Kiss []
Sex []
Marriage []
Other:

How I wish the date would have ended:

The kind of relationship I'm hoping for with this date:

None []
Friendship []
Sexual []
Move in []
Marriage []
Raise rugrats []
Other:

Will there be another date:

Yes []
No []

Notes: ..
..
..
..
..
..
..
..

My date's name:

When the date took place:

Where and how we met:

Date-rating 1-10
(1 meaning I would rather poke a stick in my eye, and 10 I can't wait to get married)

1 2 3 4 5 6 7 8 9 10

Was it the first date with this person?

Yes []
No []

My feelings before the date:

Nervous	[]
Calm	[]
Anxious	[]
Blue	[]
Horny	[]
Bored	[]
Happy	[]

Other:

My first impression:

I was wearing:

My date was wearing:

Where the date took place:

Restaurant []
Cinema []
Café []
Shooting range []
Other:

Activities. What we did during the date:

My dates occupation:

Something fun I found out about my date:

Who paid for the date:

Me []
My date []
Dutch []

The first thing that pops up when I think about my date:

This is what my parents would have thought about my date:

The things I like most about my date:

Looks []
Personality []
Humour []
Financial stability []
Other:

The things I liked least about my date:

Something embarrasing that happened during the date:

What I think my date thought about me:

The date ended with:

Handshake []
Hug []
Kiss []
Sex []
Marriage []
Other:

How I wish the date would have ended:

The kind of relationship I'm hoping for with this date:

None []
Friendship []
Sexual []
Move in []
Marriage []
Raise rugrats []
Other:

Will there be another date:

Yes []
No []

Notes: ..
..
..
..
..
..
..
..

My date's name:

When the date took place:

Where and how we met:

Date-rating 1-10
(1 meaning I would rather poke a stick in my eye, and 10 I can't wait to get married)

1 2 3 4 5 6 7 8 9 10

Was it the first date with this person?

Yes []
No []

My feelings before the date:

Nervous	[]
Calm	[]
Anxious	[]
Blue	[]
Horny	[]
Bored	[]
Happy	[]

Other:

My first impression:

I was wearing:

My date was wearing:

Where the date took place:

Restaurant []
Cinema []
Café []
Shooting range []
Other:

Activities. What we did during the date:

My dates occupation:

Something fun I found out about my date:

Who paid for the date:

Me []
My date []
Dutch []

The first thing that pops up when I think about my date:

This is what my parents would have thought about my date:

The things I like most about my date:

Looks []
Personality []
Humour []
Financial stability []
Other:

The things I liked least about my date:

Something embarrasing that happened during the date:

What I think my date thought about me:

The date ended with:

Handshake []
Hug []
Kiss []
Sex []
Marriage []
Other:

How I wish the date would have ended:

The kind of relationship I'm hoping for with this date:

None []
Friendship []
Sexual []
Move in []
Marriage []
Raise rugrats []
Other:

Will there be another date:

Yes []
No []

Notes: ..
..
..
..
..
..
..
..
..

My date's name:

When the date took place:

Where and how we met:

Date-rating 1-10
(1 meaning I would rather poke a stick in my eye, and 10 I can't wait to get married)

1 2 3 4 5 6 7 8 9 10

Was it the first date with this person?

Yes []
No []

My feelings before the date:

Nervous	[]
Calm	[]
Anxious	[]
Blue	[]
Horny	[]
Bored	[]
Happy	[]
Other:	

My first impression:

I was wearing:

My date was wearing:

Where the date took place:

Restaurant []
Cinema []
Café []
Shooting range []
Other:

Activities. What we did during the date:

My dates occupation:

Something fun I found out about my date:

Who paid for the date:

Me []
My date []
Dutch []

The first thing that pops up when I think about my date:

This is what my parents would have thought about my date:

The things I like most about my date:

Looks []
Personality []
Humour []
Financial stability []
Other:

The things I liked least about my date:

Something embarrasing that happened during the date:

What I think my date thought about me:

The date ended with:

Handshake []
Hug []
Kiss []
Sex []
Marriage []
Other:

How I wish the date would have ended:

The kind of relationship I'm hoping for with this date:

None []
Friendship []
Sexual []
Move in []
Marriage []
Raise rugrats []
Other:

Will there be another date:

Yes []
No []

Notes:

My date's name:

When the date took place:

Where and how we met:

Date-rating 1-10
(1 meaning I would rather poke a stick in my eye, and 10 I can't wait to get married)

1 2 3 4 5 6 7 8 9 10

Was it the first date with this person?

Yes []
No []

My feelings before the date:

Nervous	[]
Calm	[]
Anxious	[]
Blue	[]
Horny	[]
Bored	[]
Happy	[]

Other:

My first impression:

I was wearing:

My date was wearing:

Where the date took place:

Restaurant []
Cinema []
Café []
Shooting range []
Other:

Activities. What we did during the date:

My dates occupation:

Something fun I found out about my date:

Who paid for the date:

Me []
My date []
Dutch []

The first thing that pops up when I think about my date:

This is what my parents would have thought about my date:

The things I like most about my date:

Looks []
Personality []
Humour []
Financial stability []
Other:

The things I liked least about my date:

Something embarrasing that happened during the date:

What I think my date thought about me:

The date ended with:

Handshake []
Hug []
Kiss []
Sex []
Marriage []
Other:

How I wish the date would have ended:

The kind of relationship I'm hoping for with this date:

None []
Friendship []
Sexual []
Move in []
Marriage []
Raise rugrats []
Other:

Will there be another date:

Yes []
No []

Notes: ..
..
..
..
..
..
..
..
..